ABC

ROY LICHTENSTEIN'S

abc

Conceived and written by
BOB ADELMAN

Designed by Samuel N. Antupit

Thames & Hudson

First published in the United Kingdom in 2013 by
Thames & Hudson Ltd, 181A High Holborn,
London WC1V 7QX

British Library Cataloguing-in-Publication Data
A catalogue record for this book is available from the British Library

ISBN: 978-0-500-51683-6

Printed and bound in Italy by EBS

To find out about all our publications, please visit **www.thamesandhudson.com**.
There you can subscribe to our e-newsletter, browse or download our current catalogue,
and buy any titles that are in print.

ACKNOWLEDGMENTS

Visual books are always collaborations.

In a difficult time, Dorothy, David, and Mitchell Lichtenstein's enthusiasm for ABC was heartening.
The managing director of Roy's studio, Cassandra Lozano, ably assisted by Joanna Johnson, led us
cheerfully and expertly through Roy's artistic cornucopia. Shelley Lee nimbly and unflappably
overcame any and all obstacles standing in the book's way.

I would especially like to thank Jamie Camplin, our Peerless Publisher,
for immediately saying a delightful three-letter word: Y-E-S!

Sam Antupit, dean of typography and a 26 letterman, graced these pages with his intricate knowledge
and refined sensibilities to typeface and design. Liz Trovato's formidable skills are displayed on every page.

I am especially indebted to Mary Beth Brewer, bookmaker extraordinaire,
who worked her magic on every aspect of this book from its inception.

Roy's work is replete with words and letters, and he loved good talk. The alphabet is based on type that
he used in his art. Although Roy was with us at the start, ABC has now turned into an homage, alas.

—Bob Adelman

FOR HENRY LICHTENSTEIN, HARRY, EDDIE AND TORI REAY
GRAND CHILDREN

FOR ROY WHO IS ALIVE AND WELL ON MUSEUM WALLS
AND IN GREAT COLLECTIONS AROUND THE WORLD,
ALL HE KNEW OR WANTED IN THE WAY OF IMMORTALITY.

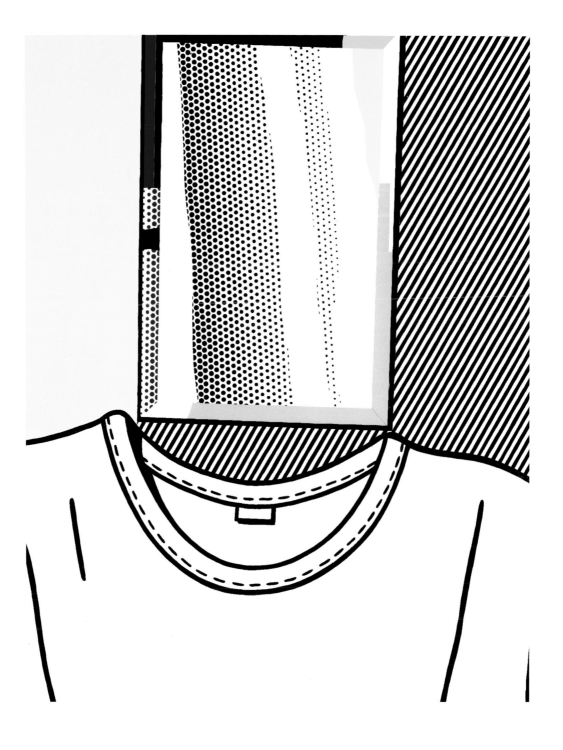

ROY LICHTENSTEIN'S
PAINTINGS ARE MADE UP OF
LINES, COLORS, DOTS, STRIPES, AND
SOMETIMES WORDS. TOGETHER THESE
ARE HIS LANGUAGE.

WHEN WE TALK, WRITE, OR READ,
ALL OF US USE WORDS.
WORDS ARE MADE UP OF LETTERS.

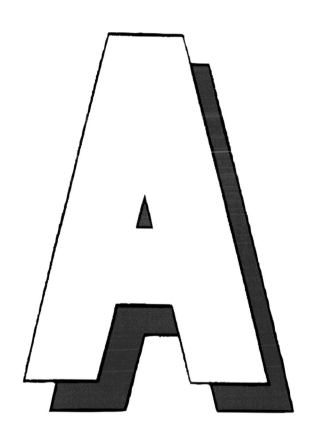

ART

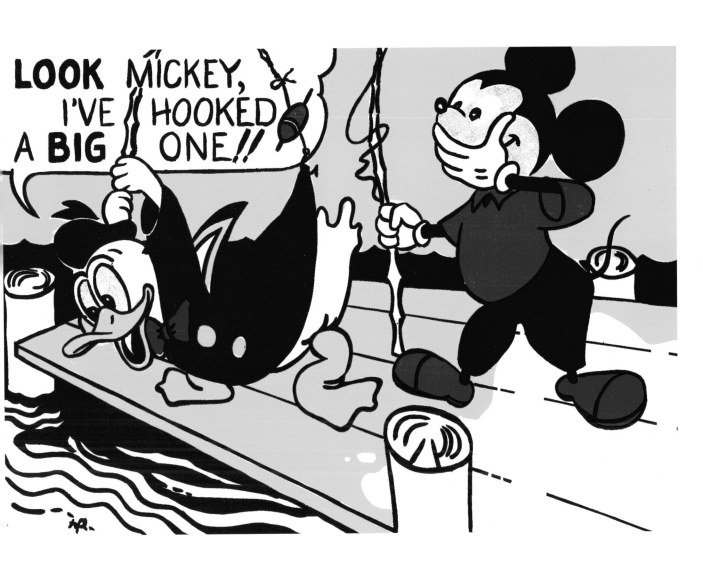

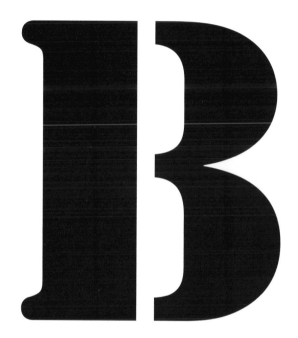

Barn Black Blue

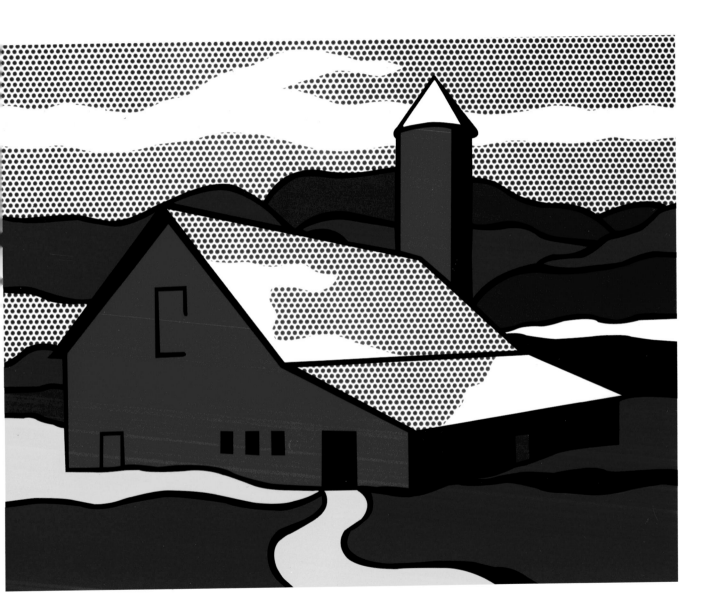

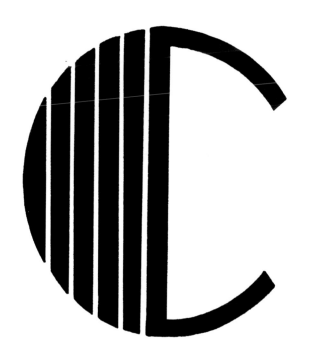

Cup Coffee Curves

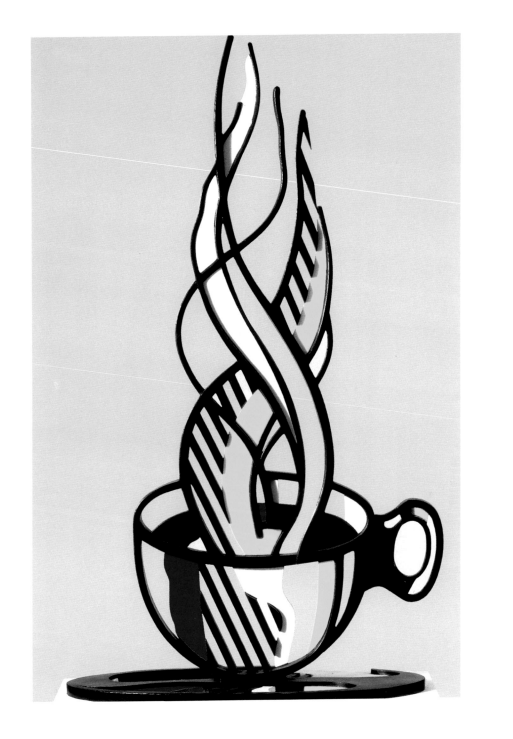

Dog Dots

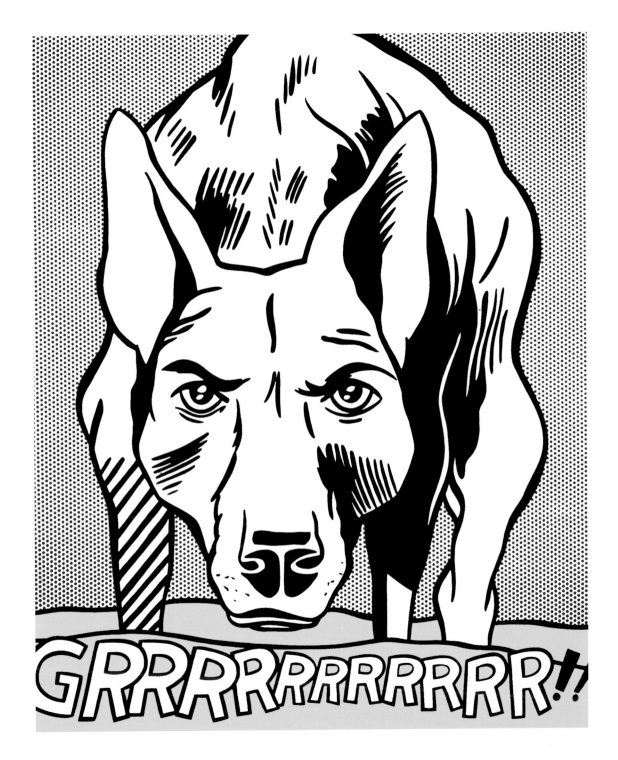

Explosion Edges

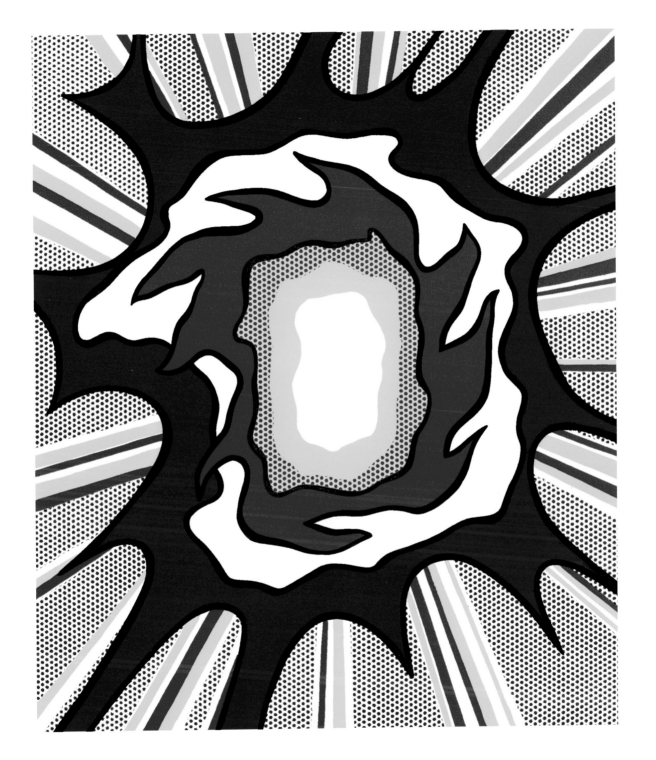

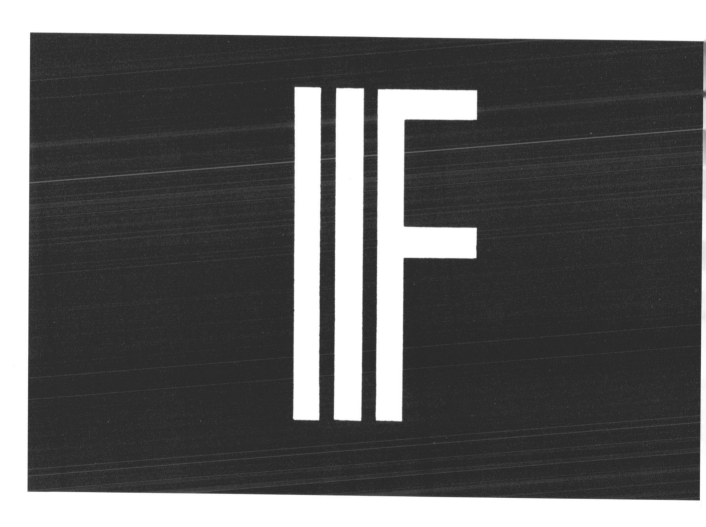

Flag Flat Form

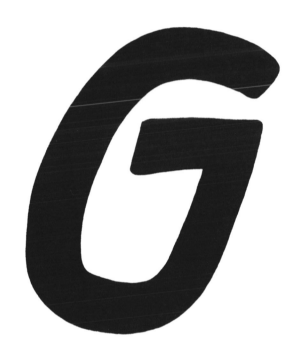

Golf Ball Goldfish Grapefruit Glass Green

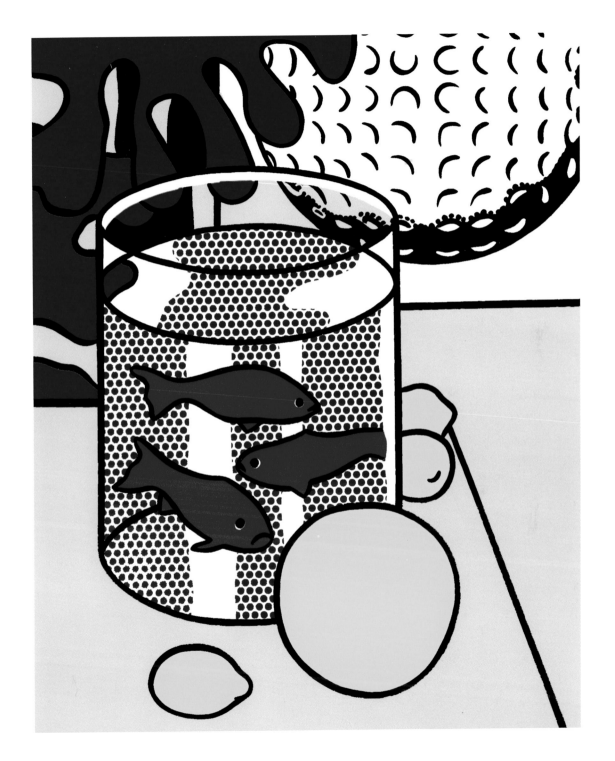

Horses Hoofs Heads Hands

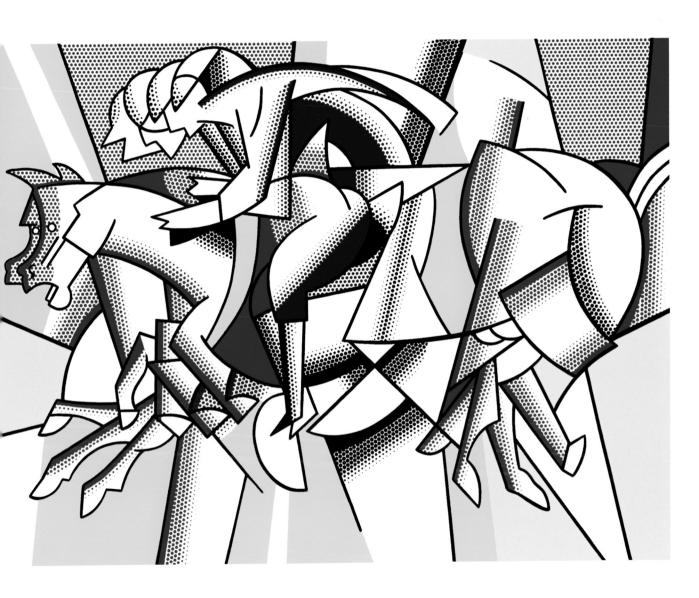

Ice-Cream Soda

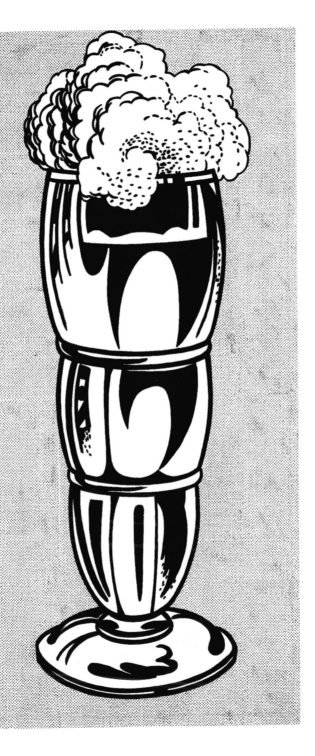

J

Jazz

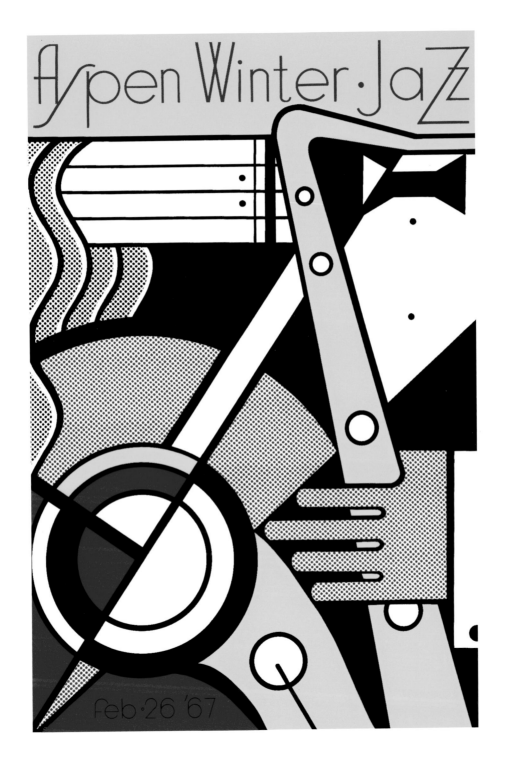

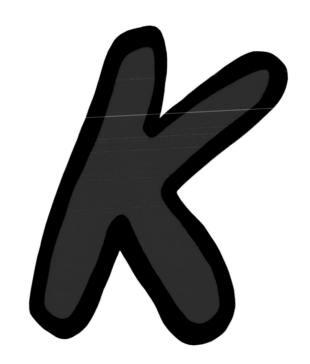

Kiss

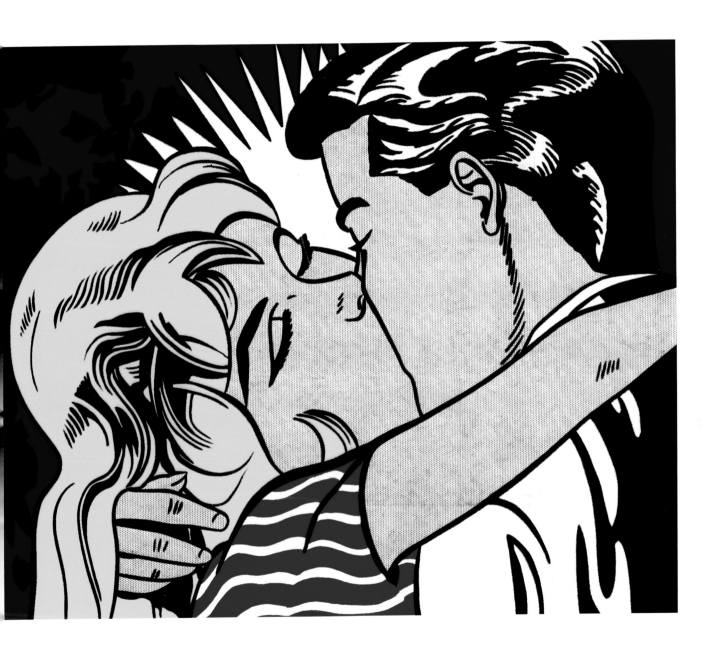

Lobster Lighthouse Legs Lines

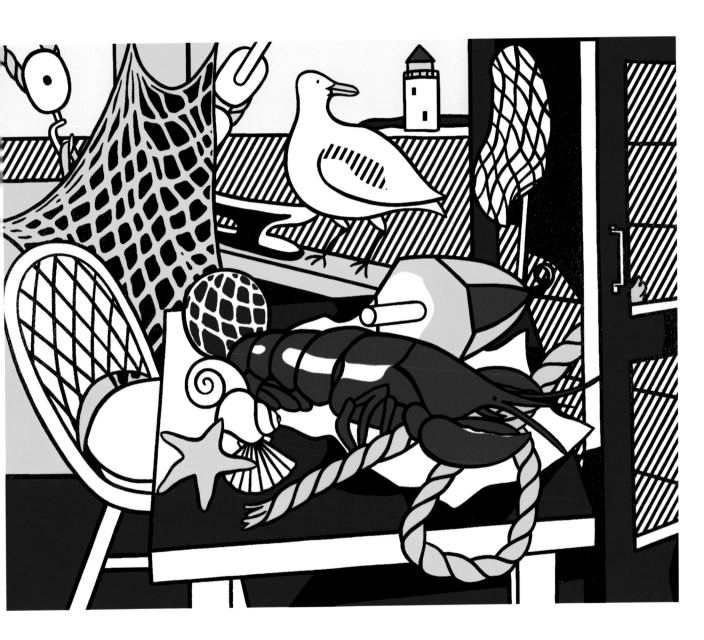

Mermaid Model

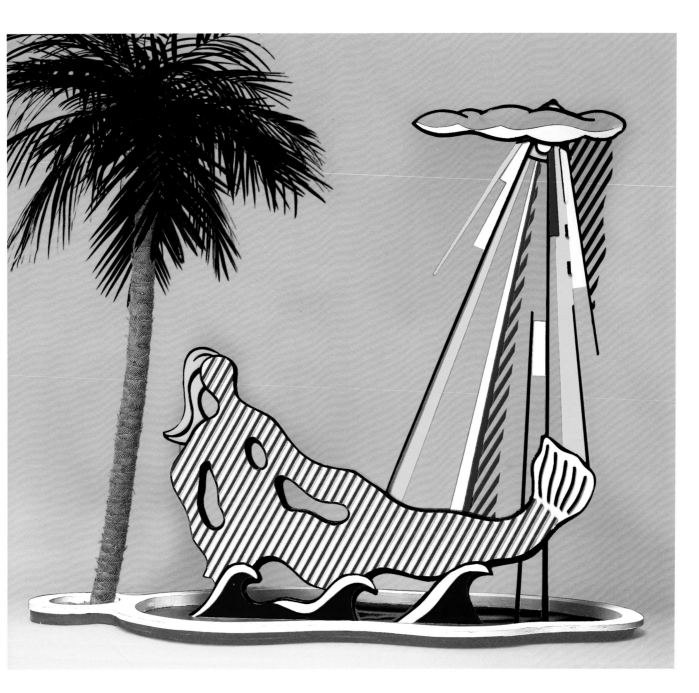

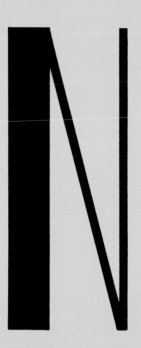

Nurse Nose Neck Nails

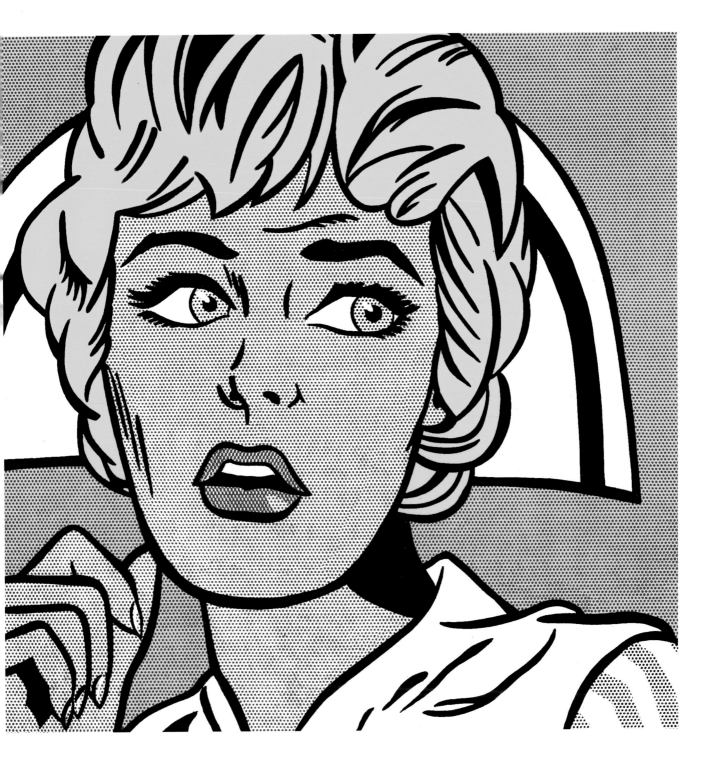

Oval Office

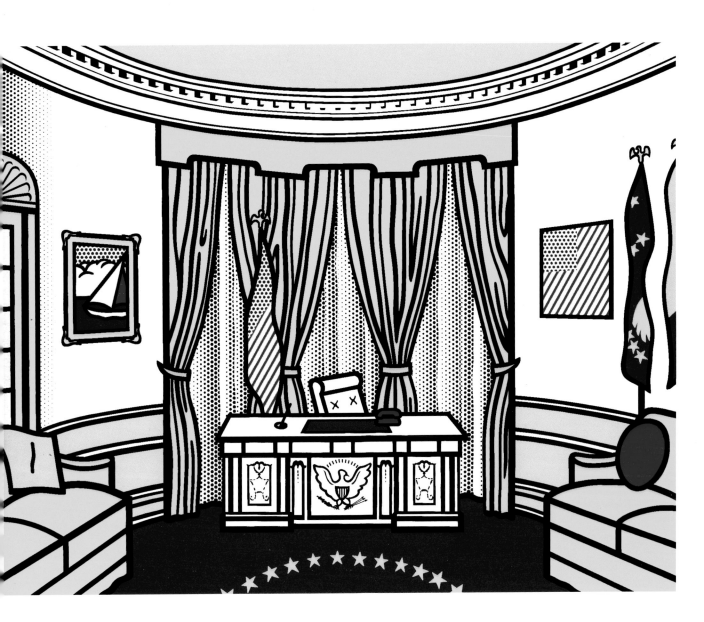

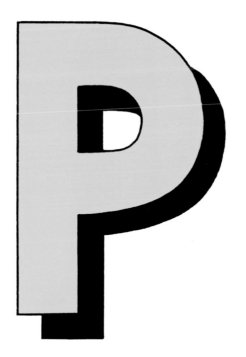

Pyramids Perspective Planes Point

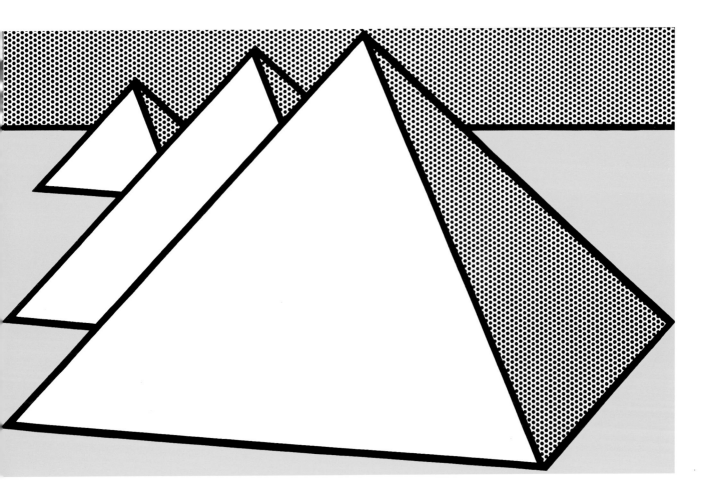

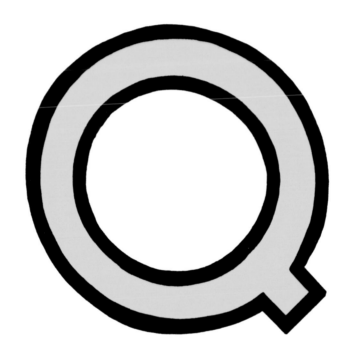

Quack! Quack!

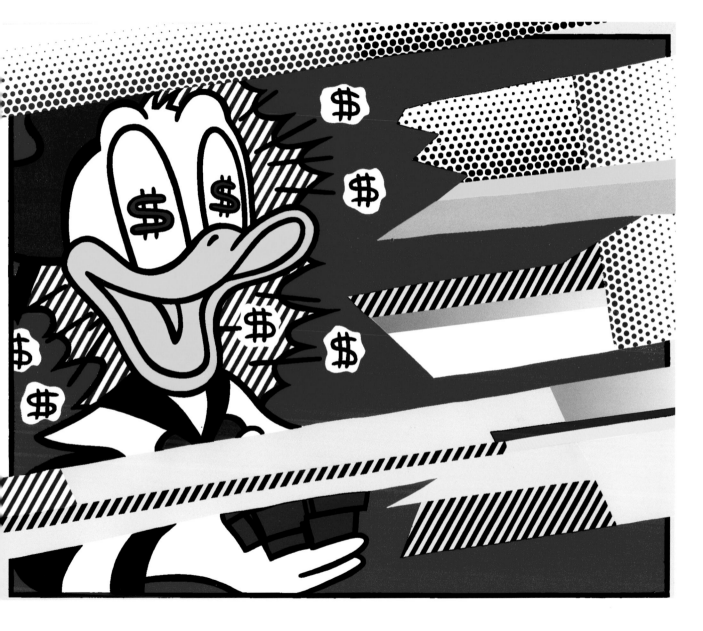

R

RING!

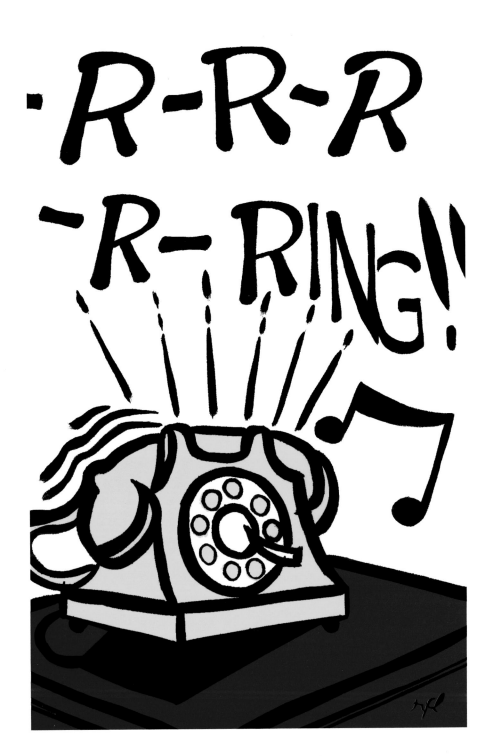

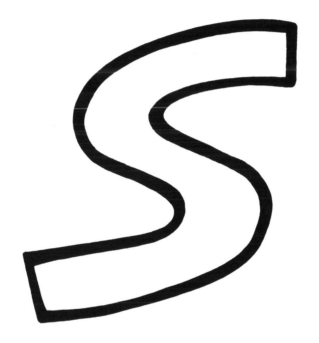

Soda Straw Sliced Sandwich

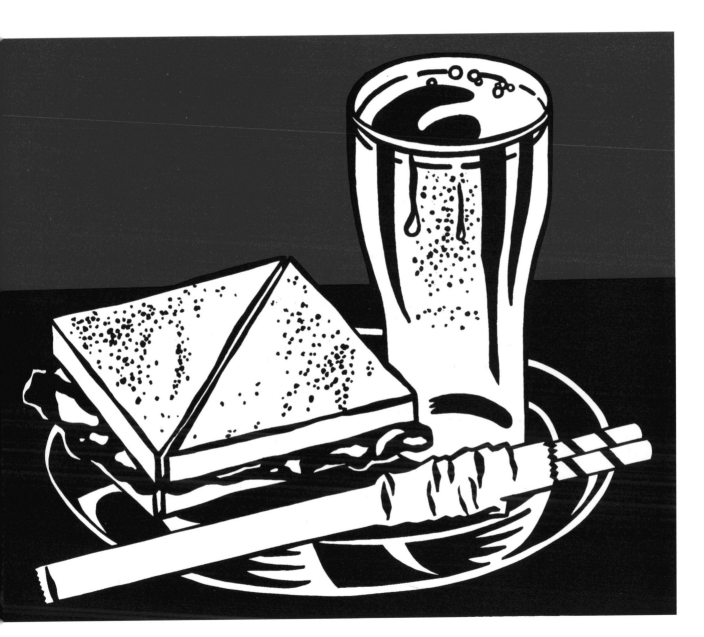

T

Tears Throat Teeth

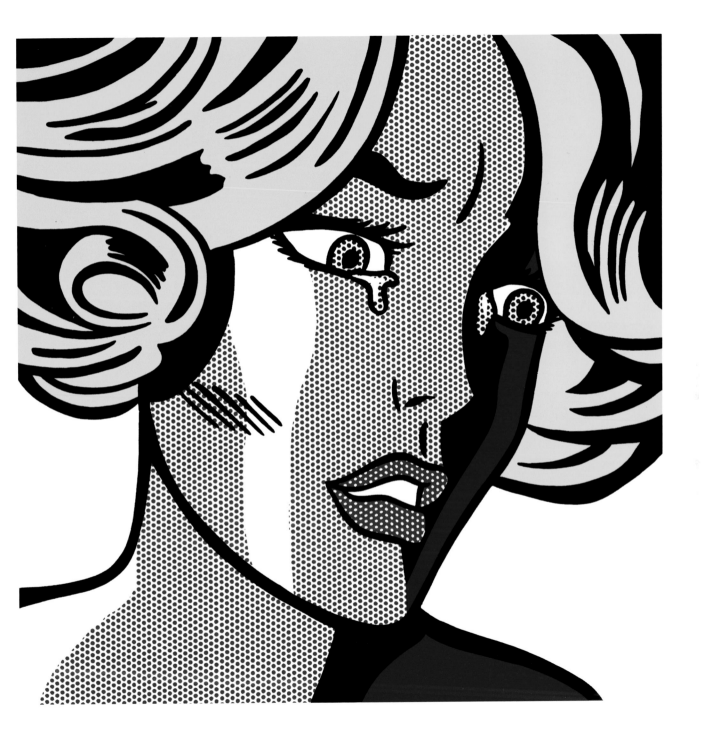

Uniform

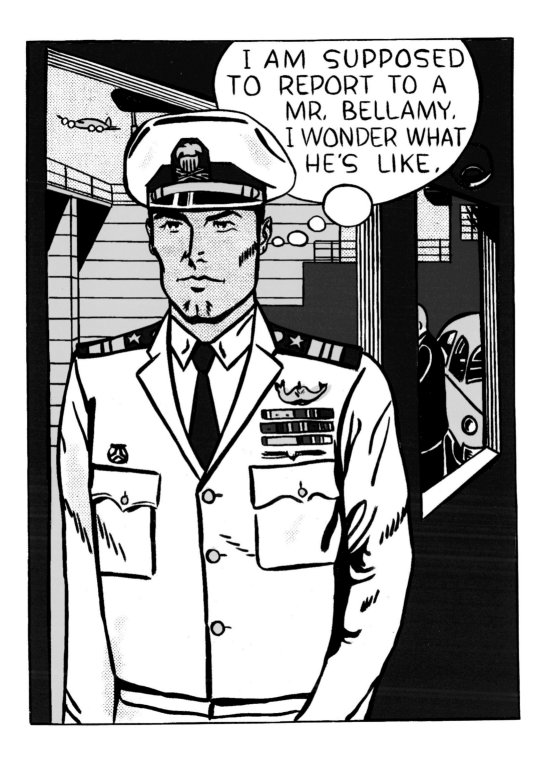

Violin Violinist

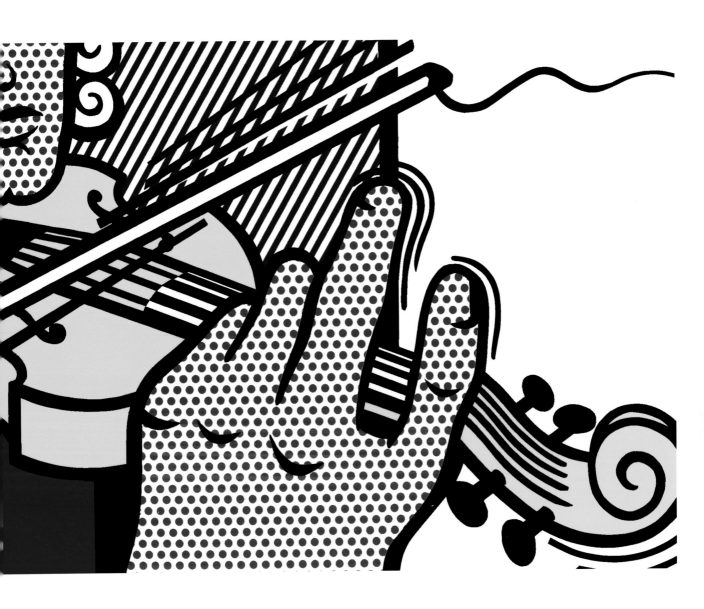

Water Lilies Water White

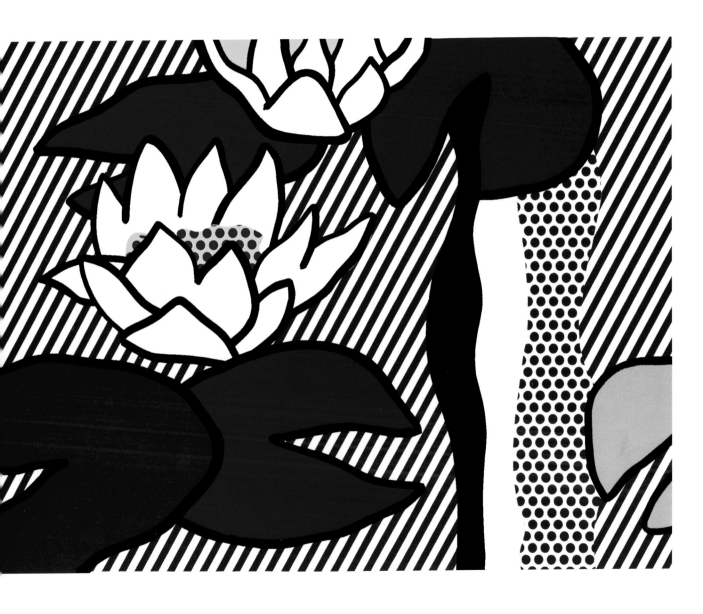

X-in

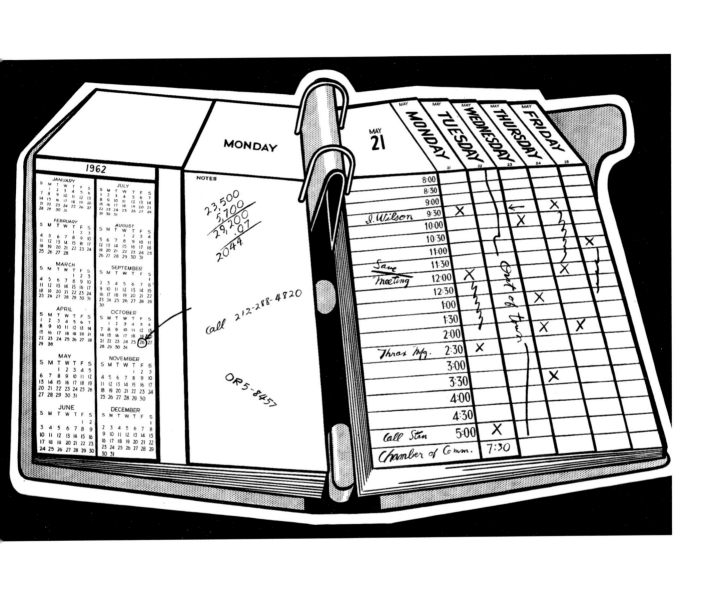

Yellow

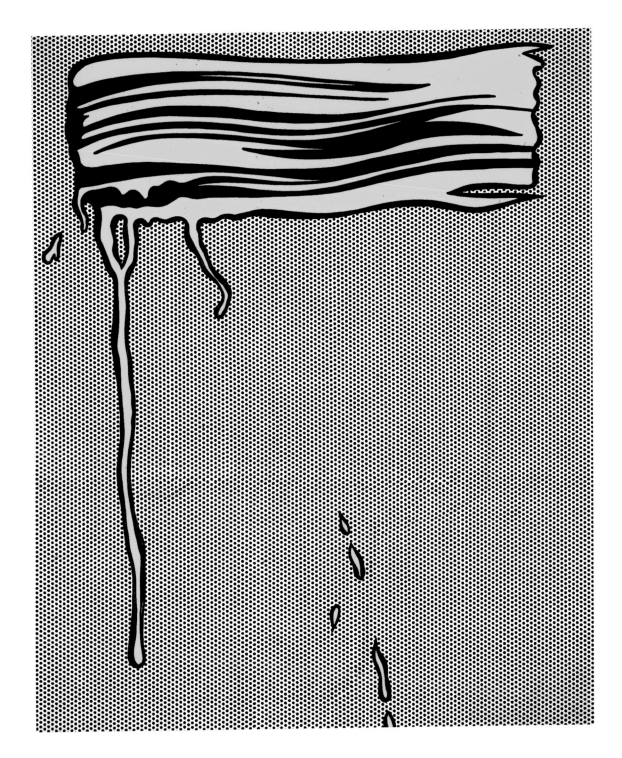

Zipper

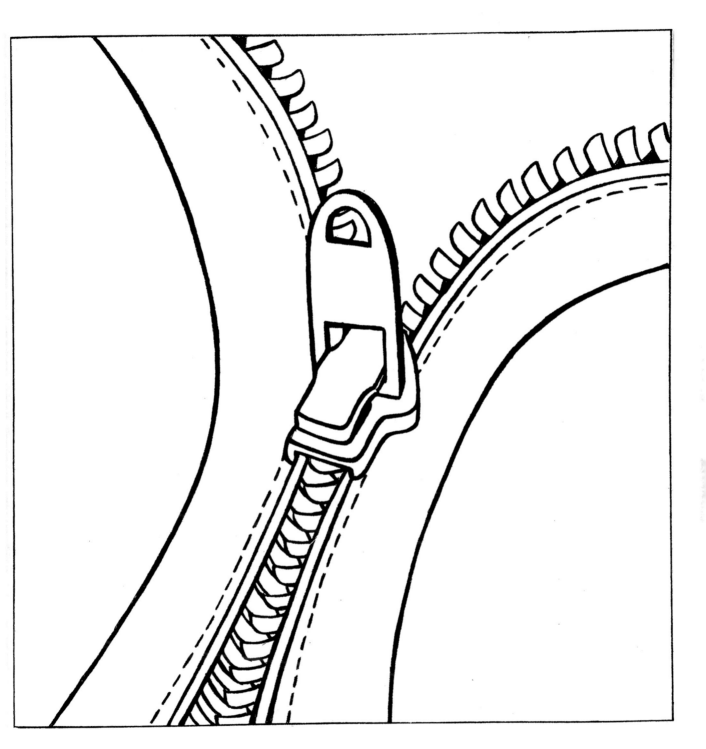

LIST OF PLATES

All dimensions are given in inches, height before width.

Page 6
Self Portrait, 1978
Oil and magna on canvas
70 x 54
Private collection

A
Art, 1962
Oil on canvas
36 x 68
Private collection

Look Mickey, 1961
Oil on canvas
48 x 69
National Gallery of Art,
 Washington, D.C.

B
Red Barn II, 1969
Oil and magna on canvas
44 x 56
Museum Ludwig, Cologne, Germany

C
Cup and Saucer II, 1977
Painted and patinated bronze
Sculpture: 43 3/4 x 25 3/4 x 10;
 base: 20 x 12 x 27; edition of 3
 and maquette
Private collection

D
Grrrrrrrrrrr!!, 1965
Oil and magna on canvas
68 x 56
Solomon R. Guggenheim Museum,
 New York

E
Explosion, 1965
Oil and magna on canvas
56 x 48
Private collection

F
Forms in Space, 1985
Screenprint on Rives BFK paper
Sheet: 35 3/4 x 52;
 Image: 31 1/8 x 42 1/2
Edition: 125
Private collection

G
*Still Life with Goldfish (and
 Painting of Golf Ball)*, 1972
Oil and magna on canvas
52 x 42
Private collection

H
The Red Horseman, 1974
Oil and magna on canvas
84 x 112
Ludwig Collection, Museum
Moderner Kunst, Vienna, Austria

I
Ice Cream Soda, 1962
Oil on canvas
64 x 32
Private collection

J
Aspen Winter Jazz Poster, 1967
Screenprint on heavy, glossy
 white paper
Sheet: 40 x 26; Image: 40 x 26
Edition: 300
Private collection

K
Kiss II, 1962
Oil on canvas
57 x 68
Private collection

L
Cape Cod Still Life II, 1973
Oil and magna on canvas
60 x 74
Private collection

M

Mermaid (sculpture maquette), 1978
Painted wood
59 1/4 x 70 3/4 x 34
Private collection

N

Nurse, 1964
Oil and magna on canvas
48 x 48
Private collection

O

Oval Office, 1993
Oil and magna on canvas
126 x 161
Private collection

P

Study for "The Great Pyramid," 1969
Oil and magna on canvas
43 x 68
Private collection

Q

Reflections: Portrait of a Duck, 1989
Oil and magna on canvas
50 1/8 x 60 1/8
Private collection

R

-R-R-R-R-Ring!!, 1962
Oil on canvas
24 x 16
Private collection

S

Sandwich and Soda, 1964
Screenprint on clear plastic
Sheet: 20 x 24; Image: 19 x 23
Edition: 500
Private collection

T

Frightened Girl, 1964
Oil on canvas
48 x 48
Private collection

U

Mr. Bellamy, 1961
Oil on canvas
56 1/2 x 42 1/2
Modern Art Museum of Fort
 Worth, Texas

V

Salzburger Festspiele 1991
 (collage for poster), 1991
Painted and printed paper on board
21 1/4 x 28 3/16
Private collection

W

Les Nymphéas
 (collage for print), 1992
Painted and printed board on paper
26 1/4 x 35 7/8
Private collection

X

Desk Calendar, 1962
Oil on canvas
48 1/2 x 68 1/4
Museum of Contemporary Art,
 Los Angeles, Panza Collection

Y

Yellow Brushstroke I, 1965
Oil on canvas
68 1/8 x 55 7/8
Kunsthaus, Zurich, Switzerland

Z

Zipper, 1962
Graphite on paper
Sheet: 22 1/2 x 19 3/4;
 Image 15 x 14 1/2
Private collection

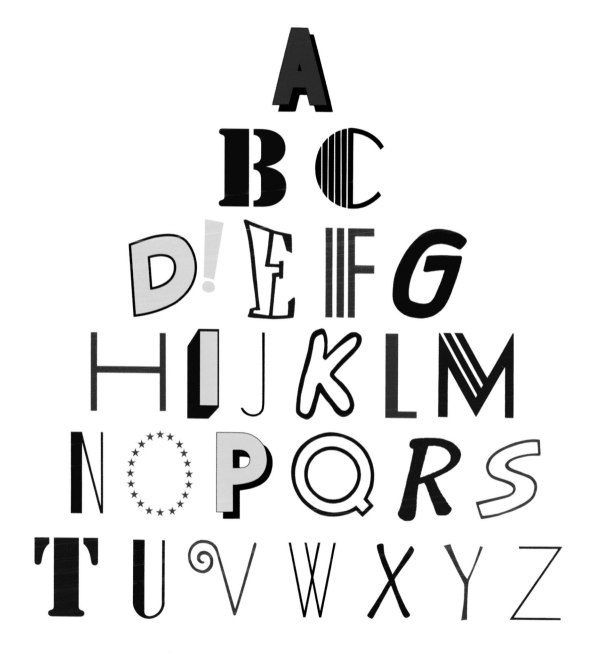

Art books are usually printed in a combination of standard colors. Here, however, we have matched the colors to actual paint chips from Lichtenstein's palette. Thus red, blue, yellow, green, and black as they appear on the page duplicate as closely as possible the colors found in the original art.

Each of the alphabet letters has been drawn by hand, but all are based on letters that appear in Lichtenstein's art. The letters J, W, and Z are based on the typeface Futura. L, N, and U are from Radiant, the face used in Lichtenstein's posters for Lincoln Center's jazz festival and for the Guthrie Theatre's *Merton of the Movies*. B and T are done in Stencil, the face used on his 1993 CARE poster. E comes from an early lithograph, *Ten Dollar Bill,* and K and S are based on comic-strip lettering. F and M originate from the word FORM, part of his mural *Large Interior with Three Reflections.* In a few cases, the letters are reproduced directly from the works illustrated: For example, R is from *-R-R-R-R-Ring!!*

The text of the book is set in Tekton Oblique inspired by comic-strip lettering. Tekton is an Adobe Originals typeface designed by David Siegel in 1989.